Connecting

Nature

Connecting

Dedication

I'd like to dedicate this book to all my wonderful soul sisters... You know who you are. Thank you for walking alongside me on my meandering path, enjoying each and every day.

Also a special dedication must go to my beautifuls, Harry, Jaxson and Florence. Never stop talking to the worms and being curious, my little darlings. I love you loads xxx

SEARCH PRESS

with Nature

TILLY ROSE

Mindful stitching and textile art through the seasons

First published in 2025
Search Press Limited,
Wellwood, North Farm Road,
Tunbridge Wells, Kent TN2 3DR

Text copyright © Tilly Rose, 2025
Photographs on pages 110 (top), 114 and 121 by
Juan Hayward. All other photographs by
Mark Davison at Search Press studios and on location
Design copyright © Search Press Ltd. 2025
Every effort has been made to obtain permission to reproduce quoted material.

All rights reserved. No part of this book, text, photographs or illustrations may be reproduced or transmitted in any form or by any means by print, photoprint, microfilm, microfiche, photocopier, video, internet or in any way known or as yet unknown, or stored in a retrieval system, without written permission obtained beforehand from Search Press. Printed in China.

ISBN: 978-1-80092-191-7
ebook ISBN: 978-1-80093-176-3

The Publishers and author can accept no responsibility for any consequences arising from the information, advice or instructions given in this publication.

Readers are permitted to reproduce any of the projects in this book for their personal use, or for the purposes of selling for charity, free of charge and without the prior permission of the Publishers. Any use of the projects for commercial purposes is not permitted without the prior permission of the Publishers.

Suppliers
If you have difficulty in obtaining any of the materials and equipment mentioned in this book, then please visit the Search Press website for details of suppliers: www.searchpress.com

Bookmarked Hub
For further ideas and inspiration, and to join our free online community, visit www.bookmarkedhub.com

About the author
For more information about the author, you can find her via:
www.tilly-rose.co.uk
Instagram: @tillyrosevintage
Facebook: Tilly Rose – Textile Artist

Acknowledgements
A huge thank you to Lyndsey, Maz and Mark for all their hard work in helping me share my love of Mother Earth with so many others...

Contents

Introduction 6

Creative approaches 10

Foraging and gathering resources 12

Botanical eco-dyes and paints 22

Botanical journals and chapbooks 32

Weaving 36

Slow stitching 42

Seasonal Projects 46

WINTER

A Little Hygge
Showcasing treasures ... 48

Treasured Memories
Memory sticks ... 52

A Walk with Flora
Botanical journal ... 62

SPRING

Patterns in Nature
Stitch diary ... 72

Dancing Ballerinas
Nature mandala ... 78

SUMMER

Seascapes
Woven collage ... 88

The Language of Flowers
Mini flower press ... 94

A Moment in Time
Sun printing ... 104

AUTUMN

Nature's Gems
Garland ... 110

Fallen Leaves
Artist's brush wrap ... 114

A Fenland Sunset
Eco-dyed wall hanging ... 120

Inspiration

Blessing: Textile collage ... 124

Stitchery 128

Introduction

I've been compelled by curiosity.
Mary Leakey (paleoanthropologist) 1913–1996

Hello, my lovelies... A huge welcome! Goodness, my fourth publication! How did that happen?

I am so excited to bring you this book, celebrating my love of creativity in combination with my love of nature. It is an insight into all the inspiration that surrounds me in my daily living at home and at work.

I have always been an 'outside' rural kind of girl even though I grew up in a city. Since I was a small child I've always needed to feel the wind through my wild curly hair, feel the fresh air on my cheeks, watch the clouds float by and step among the dewy grass with my bare feet at every opportunity.

As an adult, I learned how deeply rooted it is in my bloodline and DNA and I didn't really have a choice! I originate from a long line of native Fenlanders, Vikings, old East Anglians and wild wanderers.

My homeland is in the Cambridgeshire Fens in the UK; an area of outstanding beauty that has been tamed by man by reclaiming the land from the sea over centuries of toil and wrangles with Mother Earth. The Fens are renowned for their flatness, enormous open skies and ferocious winds... If I had to sum up in three words what they mean to me, it would simply be: * Light * Reflections * Immense*.

I am lucky to be surrounded by nature daily: 'Little Nell' is my home, nestling by an ancient brook on the edge of the city of Peterborough, and 'The Habby Hut' is my work studio, just over the border in the Lincolnshire Fens, offering vast skies and emptiness.

Why write a book about creating with Mother Earth? Well, the two go hand in hand in my creative world and I am hoping I can give you some ideas and inspiration that will introduce you a little more to that wonderful world of natural creativity.

Capturing the beginnings of autumn...

I hope to persuade you to look at your own crafting in a more natural way using the wonderful resources you can find all around, even if you don't live in the countryside or have a garden. Many studies have shown that being connected to nature in some small way greatly enhances our well-being.

I also show you how to combine resources such as cloth, wool and any embellishments you may have in your craft stash with natural treasures found on walks, trips to local parks or on holiday, to create some wonderful projects. These capture memories and tell your own story along the way.

You may know I am a mixed-media textile artist, tutor and storyteller, but another important aspect of my life is that I'm a pagan druid who has a huge connection with and deep respect for Mother Earth.

That doesn't mean I walk around in a cloak, hiding out in bizarre locations, as TV dramas would have you believe, it just means I welcome each season with open arms and value all the joys they bring throughout the year.

I deeply respect the Earth with a gentleness, walking my own path in a solitary way. I love to say good morning to the sun and goodnight to the moon, to embrace the ferocious wild Fen winds, dance in the rainy puddles after a storm and wash my toes in the watery streams or sea.

I am a wild wanderer who forages and collects materials to work with, am inspired by all natural elements and follow the Wheel of the Year throughout the seasons. I celebrate each new month with a gentle positivity like our ancestors did and try to work alongside Mother Earth, using the riches she offers either as inspiration or as actual resources in my projects.

Although I live on the edge of a busy city, I am only two minutes away from the openness of the wild Fenlands, and I feel very lucky to have the best of both worlds. My family moved to Peterborough when I was five. Our back garden was the size of a postage stamp and our front garden was non-existent. I have a lovely early memory of chrysanthemums, a few snapdragons and a small patch of rhubarb in the back garden. Every time I smell chrsyanths now, I am reminded of that garden. Isn't it funny how little memories stay with you?

The main park was only a five-minute walk away. It played a very important part in my early life and became my second home. It was an area that I felt safe and 'free' to roam in.

As an adult, I realize how valuable this outside space was. I watched many seasons come and go – the carefully manicured lawns burn in the scorching summers, tree branches fall in the harsh autumnal winds and conkers fall from the mighty horse chestnut trees. I was mesmerized by the tiny crocuses appearing in the snowfall, the delicate lacy cobwebs dangling in the dazzling sunlight, and the squirrels performing gymnastics in the firs. I collected 'treasures' such as twigs, leaves, pinecones, seedpods and twirling sycamore helicopters, never knowing if I might use them.

All those wonderful memories create the foundation for so many of my designs, projects and workshops. Without that outdoor freedom, I wouldn't be the person I am today.

I was lucky enough to share the park with my sons when they were young, so my love of the outdoors continues through them and their families. It also continues with my readers too...

I hope you enjoy dabbling into my magical world of natural crafting and feel inspired to try a new craft.

Tilly x

Creative approaches

In this section I introduce you to some of the techniques I use on a regular basis that form the foundation to all of my projects.

Each technique shown is interchangeable with other crafts and projects. I have included a few tips on making them accessible for all abilities and ages.

They are also wonderful to share with your family, friends young and old or with other crafters within your community groups and connect with the natural world around you.

What is this life if, full of care,
We have no time to stand and stare?–

Extract from *Leisure* by W. H. Davies (1871-1940)

Foraging and gathering resources

I am a forager and an avid collector of all sorts! My family are so used to seeing me with full pockets that they don't question it anymore.

I love nothing more than being left alone to look for goodies on a walk among the greenery or earthy moss of a woodland; among the wildflowers in a meadow or even in among the ancient pastures of a churchyard.

There is so much inspiration in collected treasures that are often missed simply because as adults we forget to 'collect'. We accept that it is okay for children to pick up everything and we actively encourage them to do so. As adults, we often forget to do the same ourselves.

We never lose that childhood curiosity, so if you allow that wandering eye to go with you, then you'll get into the habit of foraging and collecting even if you are walking alone.

Nature calms the mind and soul. It enables us to contemplate the essence of life and brings a deeper appreciation of what it means to live fully.

What inspires you?

On your walks, look carefully at the patterns, texture and colours of your surroundings. You may be inspired or intrigued by all kinds of different finds. What appeals to one person may not to another.

I always make sure I have my phone with me for taking reference photographs. You may also wish to keep a treasure as a reminder of where you have visited, such as a pebble from the beach or a fallen twig from a forest you've enjoyed walking through. These will form the foundation of a lovely collection; a brilliant three-dimensional moodboard a bit like my 'A Little Hygge' project on page 48.

If you place your treasures in a communal space, it allows visitors to your home or craft room to enjoy them too. You can keep them in empty jam jars, vintage vases, old teapots or biscuit tins. I love finding old pottery jars and bottles to store my treasures in. For me, displaying them is just as enjoyable as finding them. These collections form part of my décor and become part of my home.

In time, your display will present itself as a form of textured art and it will probably change throughout the seasons as you add to your collection.

Forage = to search, scrabble around, rummage, explore, scour, hunt for

Note

I must add a note about being kind and respectful to our environment. As you collect your treasures it is important to be mindful of the generations who will walk in our footsteps. Although there may be hordes of pebbles on the beach today, we need to be respectful to Mother Earth and think of our planet in centuries to come by leaving plenty for others.

I hope my 'rules of kindness' help. Please...

- Don't trample over wildflowers or vegetation trying to gather something.
- Don't pick anything from sites of special scientific interest (SSSI).
- Don't be greedy: one or two pebbles are gifts. You should not take a gardenful.
- Be kind to Mother Earth and leave only your footprints after your visit.
- Always say a little thank you for the gifts you find.

14 Connecting with Nature

Collecting found treasures

Here I want to show you the sort of things that I love to collect on my travels, the things that inspire me and also the treasures that intrigue me. Each found treasure is individual and tells its own story.

I have grouped my collections into five different landscapes.

Woodland/forest/ancient woods
Found items like twigs, conker shells, bark and feathers would look lovely displayed in wooden bowls or baskets as a seasonal collection.

Beach/coastline/cliff top
Treasures such as shells, seaweed, driftwood and fishing twine are perfect to include in textile collages, wall hangings or interchangeable décor in your home.

Garden/park/ community garden

Seedheads, petals and herbs like those pictured on the left are ideal for adding to gift tags, handmade cards, wedding favours and invitations.

Marshland/ wetland/ riverbank/pond

Dried seedheads, grasses and sedge reeds like these would look lovely displayed in old glass jars on a shelf. Place them by a window and see how the sunlight adds to their beauty.

Wild meadow/grassland/wild pasture

Seedpods, dried grasses and petals are a beautiful reminder of lazy summer picnics. Store in glass jugs and build up your collection as the season changes.

Storing your collections

It is important to make sure all your found treasures are dry, free from mould or mildew and not starting to rot. Also look out for creepy crawlies who like to stay hidden. Check your collected items regularly to make sure they are still okay. Nothing is permanent, so be prepared to lose some treasures along the way.

Try not to keep your treasures in plastic. Instead, use natural elements to allow your items to breathe. I usually keep my delicate treasures such as broken shells wrapped in tissue paper and snuggled safely in devoted boxes. I keep my pressed leaves and flowers in old vintage books or trays ready to use in projects. Generally though, I like to see my treasures on display. Don't forget to label them too.

Sometimes I'm a little haphazard with finding a suitable home for my treasures. I put something down temporarily and realize months later that I've forgotten to arrange it. I usually decide that since it's survived in that spot I will keep it there!

Here are a few examples of items I've stored.

I have put all of my memory sticks in a vase, but you can choose a large jam jar, a basket if your sticks are really long or just a normal plant pot. Think creatively and go bold if you dare!

18 Connecting with Nature

This lidded jar is perfect for storing shells I have collected.

I hang fresh flowers from the ceiling in my studio to allow them to air dry.

Pressing flowers and herbs

Flowers have been collected for centuries and there is documentation of pressed petals found as far back as Ancient Egyptian times.

Pressing flowers and leaves is another form of storytelling. It allows you to preserve the beauty of nature in a way that is both simple and long-lasting.

The joy of placing flowers in books is that you sometimes forget they are there and have a wonderful surprise when you open up the books again.

20 Connecting with Nature

Unlike fresh flowers, which sadly wilt and die, pressed flowers can last for years, providing you with a beautiful keepsake telling their story – treasured love tokens from a secluded stroll, mementoes of holidays, gifts given by little ones.

Whenever I go for a walk, I collect a few flowers, to hold on to that gentleness for as long as I can on my return. But it is not just wildflowers I collect. I like to use all kinds of flowers and herbs: birthday bouquets, bunches bought from a supermarket or cuttings taken from my garden reminding me of summery days in the cold wintry evenings.

Drying your flowers

Before using flowers for a project, they need to be collected gently, stored flat and pressed until dry. This will give you a gorgeous collection of blooms to work with.

Make sure you pick your flower after the morning dew has dried. Any moisture left on the petals will create a mouldy pressed mush which will make it unusable.

Lay your chosen flower or herb carefully onto a piece of paper or on to the page of a book. I love using vintage books from thrift shops and I have piles of these housing a lovely selection of blooms collected over the years.

If you don't have a vintage book, you can create a pile of flower paper sheets using cartridge paper or Indian rag paper as they are good for letting your flowers 'nestle' onto the paper. You can then simply wrap a tie around them or lay a heavy object on top while the petals dry. Alternatively, you can, of course, buy a wooden flower press.

Keep your flowers out of sunlight and lying flat for at least a week. Don't be tempted to check them as this will disturb your petals. Once dry, remove your flowers from the press and use in any project. Store them in flat containers or trays until you need them. Watch out for creepy crawlies lurking under the petals!

Wild marjoram.

A pressed hydrangea bloom. A moment with a silky pressed petal is a beautiful way of reawakening a special memory.

Botanical eco-dyes and paints

Foraging for plant material of all kinds and then taking them home to experiment with a little eco-dyeing has been an favourite pastime of mine for decades. It is the most exciting part of my textile work and, even after all these years, I am still absolutely mesmerized when I take the dyed cloth or paper out of the pot for the big reveal. That sense of serendipity and wonder is so magical!

I also love the colours that Mother Earth offers us so much more than the bright harsh synthetics we take for granted. The gentler palette helps me feel connected to her in a softer grounding sort of way. I'm sure many of you can relate to that too.

Eco-dyeing is an ancient art, a way to create colour in our lives using Mother Earth's gems.

Eco-dyeing is a form of natural dyeing where colours extracted from plants and vegetables are transferred on to paper or cloth via steaming or boiling. I first experimented with yellow onion skins, red cabbage and a few blackberries with strips of cotton muslin and cheesecloth when I was at school. I couldn't believe the process of transformation simply by placing a piece of cloth in a hot pan of water with an ordinary onion.

Over the many years since, I have delved into the history of this ancient skill, looked at ways our ancestors used natural colours in their everyday lives and how dyes can be extracted using a variety of methods. I've discovered that I prefer to use only plant material for my dyeing with no chemical mordants (colour fixers), as my skin can react so badly.

Dyeing cloth and paper in this old traditional way is gentle on Earth's resources; another positive for me. Any unused materials naturally compost back into the ground and any leftover dyed water can be used to water seedlings, completing the circle of growth for our plants.

For many, the whole alchemy of eco-dyeing, although fascinating and quite magical, can sometimes feel quite daunting. I've heard many people describe it as a minefield of worry simply because there are no guaranteed outcomes, they don't enjoy the uncertainty of experimenting, or they have no idea what will happen with their finished piece of cloth once they drop it into the pot. For me, that is the most exciting part!

Eco-dyeing is a process over which you have absolutely no control. You are combining Mother Earth's magic to transform something plain like a piece of naturally coloured cloth such as calico or plain paper, into something quite different simply by using a natural dye extracted from a plant, a vegetable or a kitchen edible. However, there are no guarantees as to what you may end up with. The result may be dull and uninspiring or it could be gorgeous.

From left to right: trumpet vine, yellow onion skin, elderberry, red cabbage.

I'm hoping to encourage you to try a little creative dabbling into the wonderful world of botanical eco-dyeing, because I know once you start you will become hooked.

The alchemy occurs when you start mixing in the power of sunshine or rainwater to your chosen dye, a long slow length of time, a little patience, and a love for watching something evolve organically, despite its unpredictability.

Out of every ten experiments, you may only end up with three or four happy smiles, or you could be lucky and have ten wonderful whole pieces of 'new' cloth.

I love to eco-dye for the gentleness of the palette you can produce using cloth, cotton threads and paper. The soft, muted, vintage colours are perfect to stitch with or write on in my journals as a foundation base, as they allow me to add in my own pop of colour when I want to.

The downside to eco-dyeing is no colour is guaranteed, no brightness is guaranteed and there is no guarantee your colour will stay permanent unless you use a mordant as a fixer. Without a mordant, it may fade in a day, in two weeks, in two months or in two years. It may not ever fade.

There are a few different ways to dye, but I am starting with the basics and assuming you are a beginner. I have described the methods for how I like to eco-dye: solar jar, simmer pot and watercolour paint.

Be experimental and keep notes. Not everything you try will be a success – some experiments will produce amazing results and others will be disappointing.

However, once you start it will become addictive. You will no doubt find jars of dye all over your rooms, picked flowers waiting to go into the simmering pot and mushy heaps of plant material just taken out and sometimes overlooked.

TIP

You can use your eco-dyed or painted pieces in so many projects – slow stitching, textile art, free-motion embroidery, experimental three-dimensional art, patchwork, quilting, papercrafting, card making, daydream journalling, scrapbook junk journalling and mixed-media collage.

My discoveries along the way

- Be creative when choosing plants. Often, colours you think may emerge won't even show. A ruby red rose will not produce a red ruby dye! That's the joy for me – finding out what secrets a plant holds and whether she will share them with you.
- The fresher the plant is, the better. It allows the plant to share their oils, sap or greenery more freely. Having said that, you can still use dried if you prefer.
- I've sometimes frozen plants if I've not been able to use them straight away, but the freezer can be quite harsh with some plants/veggies and you could end up with nothing more than a pile of mush. Simply experiment and keep notes. You will find out which way you prefer to work.
- Experiment with petals, stems, herbs, leaves, bark, pine cones, sedge reeds, dried grasses, fruit berries, vegetables, and nut shells, as well as kitchen edibles such as beetroot and onion skins.

Solar jar dyeing

Using the power of the sun is an ancient method of extracting colour from a plant or flower. It is a slow process and can be very unpredictable, but it is loved by many crafters as it is so easy to do. The simple steps below show you how to get started.

Cover your plant material with water.

Examples of solar jam jar dyes
*Nettle * blueberry * strawberry * calendula * blackberry * elderberry*

Step 1
Choose a flower you wish to try, and place a handful of petals into a sterilized jam jar.

Step 2
Fill the jam jar with water. Rainwater will produce a different colour to tap water. You may want to experiment with bottled spring water, boiled water or even melted ice water. Each one will produce a different outcome.

Step 3
Make sure your chosen plant material is covered with water, then place the jar on a windowsill in the sunlight. After a few days you will see the colour of the water change.

Step 4
If you wish to add in some cotton lace or thread, check there is no mould forming first. Simply submerge your lace, cloth or ribbon into the water and place back on your windowsill. Leave for at least a week or even two.

TIP
Check your jam jar daily for mould or mildew. If you do get some, please rest assured it isn't anything you have done. There may have been a tiny little bit nestling on your leaves or petals that you may not have noticed. Simply start afresh and repeat the process. These things can easily happen when you are working with natural ingredients.

Simmer pot dyeing

This method not only quickens the process of extracting the dye but can help intensify the colours produced. You will need a saucepan filled with cold water, a wooden spoon or tongs and lots of patience – nothing more.

TIPS

- Make sure your utensils are only ever used for eco-dyeing. Do not use anything from your kitchen used for food preparation.
- Remember you are extracting the dye in a gentle manner, not boiling it like crazy.

Heat the water in the saucepan.

Step 1
Place your chosen plant material in the saucepan and cover with cold water.

Step 2
Place the saucepan on your heat source. This can be an electric or gas cooker, firepit or electric plate. I like to use either my gas hob or an electric plate as it gives me more control over the heat settings. Turn the heat on to maximum temperature to bring the water to a gentle simmer, then reduce the heat.

Step 3
Gently simmer for an hour or two, topping up the water a little if it looks as if you are losing any through evaporation. Enjoy the slowness of watching the beautiful colour emerge. Every now and then I stir my pot, but it is not essential.

Step 4
After an hour or two turn off your heat and allow your added plant material to just 'steep' in the warmth. If it is a sunny day, I like to leave my pot outside in the sunshine for an added layer of warmth mixed with a little vitamin D for good luck.

Suggested plants to use

- Flowers – calendula * French marigold * coreopsis * sunflower * buddleia * roses * golden rod
- Vegetables – red cabbage * onions * carrot tops
- Fruit – berries * avocado skins
- Leaves – eucalyptus * willow * sage * nettle * herbs * tomato * lavender * rosemary
- Bark * cones

Once you have taken the pan off the heat you can go out and leave it with no problems. Do, of course, keep it in a safe place away from children and animals.

The alchemy of eco-dyeing often emerges in front of our very eyes but, in some cases, we have to be patient. I've found on occasion that leaving my plant material in a pan for a long time can produce the most gorgeous colours as a result. So be kind to yourself if you forget about removing it straight away. Here you can see how my white cotton lace has changed in the red cabbage.

Cotton lace dyed with red cabbage. Top: Original. Middle: After one hour. Bottom: Left in pot until the next day.

Examples of the effect of different dyes

Yellow onions: this Indian cotton rag paper was rolled up and simmered gently in a pot with onion skins for two hours, then left to cool. I left the paper in the pot for two days. You can see the beautiful rainbow of tones produced by the onion skins by leaving it longer.

Blackberry on white viscose: the simmer pot usually produces an overall coverage of colour, but you can see here it hasn't changed the white print (left). Once the viscose had dried, I dabbed over the fabric with squished blackberries to add a dappled effect (right).

Coffee on wool wadding: you can see the colour of the wool wadding (left) and how the material has soaked up the rich colour of the coffee dye (right). Coffee is great for giving a vintage look.

The following pieces of cloth, thread, ribbons, lace and paper, were all dyed using the simmer pot method on page 26.

Blackberry, cherry and Himalayan honeysuckle.

Purple buddleia blooms.

Coreopsis flowers.

Dried nettle leaves.

Dried cherry stones.

Fresh sweet pea petals.

Coffee.

Dried yellow onion skins.

Fresh red rose petals.

Creating your own watercolour paints

A really useful way to create a natural dye is to make your own watercolour paints. Although they have a limited shelf life, they are a brilliant way to explore colour. I find using herbal teabags a quick and easy option and relatively cheap too! You could share and swap different blends with friends. It's a fab way to build a lovely collection of colours to choose from.

Step 1
Boil some water in a kettle and allow to cool slightly.

Step 2
Place a herbal teabag in a jam jar then cover with hot water. The amount of water will depend how strong you want your watercolour to be but it is important to make sure your teabag is totally covered.

Step 3
Let the teabag steep until cold or until you achieve the shade of colour you want. This is a gradual process, so don't be tempted to rush.

Step 4
Remove your teabag before using the watercolour paint.

Handmade herbal watercolours
*You can use the same process for dyeing papers. Simply place your teabag on a plastic tray instead of in a jam jar amd allow the papers to nestle and soak up the colour. My favourite teabags to use are: strawberry * camomile * berry * ginger * blue pea flower * peppermint * ginseng.*

Papers dyed with teabags
I've created a rainbow chapbook using larger sheets of paper (21 x 30cm/8¼ x 11¾in) that have been dyed with herbal teabags. They make beautiful gifts and are cheap and easy to make.

From left to right: rosehip; chamomile, peppermint and ginseng; chamomile and echinacea; green tea with cinnamon and ginger; peppermint; blackcurrant; and acacia berry.

30 Connecting with Nature

'Leftovers'

If you fancy a vintage vibe to your design or you just want to take the 'newness' from your collage, why not dabble with a few leftovers? Red wine, coffee, tea and red cabbage are some of the easiest options for creating gorgeous shades of watercolour paint. Shown on the left is an example of a few papers I've dyed with coffee, ready to create my own botanicals chapbook.

You can also use your cooled watercolour paint on paper or lace. See how the pink paint has dried blue on the Indian cotton rag paper, and dried pink on the lace.

Botanical journals and chapbooks

Our seasons seem to whizz by so quickly, year after year, and are mostly unnoticed as they come and go, so keeping a journal or diary of botanical notes throughout the year is invaluable for so many reasons.

As you write notes, sketch or even just doodle, you will find yourself focusing on the finer details in front of you. You will start to notice the little changes in a flower or a tree if you watch it closely and you will begin to look at things differently and in a slower manner. You'll become more aware of the important details such as how the petals develop and uncurl in the sunshine or how leaves seem to open and perhaps close in the dewy rainfall and you'll notice when a butterfly or bee visits. You may also be more aware of the weather conditions and how they affect your observations.

Remember, botanists and botanical experts don't just acquire knowledge. Their expertise is gained over many years of study and observation. Every tiny detail is recorded for future reference, however uneventful it may seem.

It is well documented that if you focus on the smaller details in life, you will learn to appreciate the gentleness of positivity and 'be present' in the moment. In our rushed twenty-first-century way of living, I feel it is *so* important to take a moment for ourselves on a regular basis and reconnect with Mother Earth and all her beauty.

The moment one gives close attention to anything, even a blade of grass, it becomes a mysterious, awesome, indescribably magnificent world in itself.

Henry Miller (1891–1980)

Nature shows us that nothing is ever rushed and yet it always seems to come together at the right time.

Here is an example of the sort of thing I like to write down.

What to include in your journal

I have kept a botanical journal of sorts since I was at infant school. We were encouraged to sketch our observations and learn more about the environment around us as we made notes, drew doodles or collected leaves or flowers.

Most of my journals these days record the seasons through the Wheel of the Year, capturing information I discover along the way. They often include doodles of plants and trees alongside pressed leaves and flowers that I've collected for reference.

Here are a couple of pages I sketched while out watching the landscape.

My journals are not neat, precise documentations; more like assembled jumble sales of collected items full of memories and treasures! They are some of my most precious items as they contain reminders of holidays, days out with my children, visits from school days, and more.

I have added more detail such as plant names, their uses and the folklore behind each little gem I discover. Some plants occur in every one of my journals simply because I love them so dearly, such as the humble daisy or the same collection of autumn leaves.

TIP

Don't forget that any collected botanical ingredients, such as flowers or leaves, can be also used in projects from making cards, gift tags and bookmarks to larger projects such as pressed flower collages, candle lanterns and decorated picture frames.

Chapbooks

I have loved books and paper since I was a toddler and I've been making little paper books from a very young age.

My dad was a compositor for a local newspaper and he often brought home scraps of printing paper for me to colour on. All the wastepaper he recovered would be my colouring and art papers, and I created little books for my dolls, using my piles of 'odd' papers. I only discovered the name 'chapbook' in the last few years, and I smile at the connection between me making paper booklets and my dad's profession.

Chapbooks were first produced in early Europe and sold by peddlers known as chapmen. The word 'chap' comes from the Old English for 'trade', so a chapman was a dealer who sold books in towns or on street corners.

Chapbooks became timeless books of ballads, poems, tales and short stories that often sprang out of folklore. They were cheap to make and buy and they soon became the staple form of reading among the lower classes.

We often think of chapbooks as pamphlets, but originally they were single sheets of paper individually printed and loosely stitched together with a saddle stitch. Designs varied with different printers.

Chapbook flower presses

Chapbooks are perfect for storing and transporting favourite flowers and leaves collected while you're out and about. I often take a small chapbook when out walking (see 'The Language of Flowers' project on page 94) to hold my flowers in before transferring to a bigger book at home. They can then be incorporated into journals or other craft projects. Chapbooks are also ideal for recording notes and doodles. They can fit neatly inside a pocket or small rucksack.

I love to make my own chapbooks from loose sheets of paper. I show you how on pages 98–99.

This is a great opportunity to incorporate birthday cards or greetings cards as an outer cover. Creating a special outer paper for your cover or even hand stitching your own will make your booklet unique and give the content more individuality. You can never have too many chapbooks in my opinion and once you've made one, you'll become addicted to creating more!

Weaving

Most people think weaving refers to a piece of cloth or a woven scarf, but oh my goodness is it so much more! Weaving is not only the oldest form of creating a piece of cloth, it is also a form of textile art, a collage of textures, a piece of wearable art, maybe a tapestry of Boho-influenced design or even a creative floor covering...

Weaving is a calming and meditative craft that stills the mind while creating beautiful designs. Its history connects us to our past. Our ancient ancestors experimented with a whole host of different natural fibres such as nettles, flax and tree bark to discover which fibre was the strongest, the hairiest and the most durable in terms of warmth.

They created simple but effective wooden looms with weights made from rocks or stones to provide their work with some tension in order to create a recognizable piece of cloth. They spent many hours weaving and creating hand-woven cloth, cloaks, scarves, mats and shawls as part of their everyday living.

From those very basic discoveries we now have the knowledge to produce an amazing range of woven designs. I focus here on creating a collage of textures from a craft point of view rather than a woven piece of cloth for wearing.

This is a miniature version of the 'Seascapes' project on page 88.

I have woven a mixture of wool, lace, eco-dyed muslin and sari silks, raffia and cotton strips. I chose the ingredients by their colour palette to provide a beautiful backdrop for a seascape journal cover. I will probably embellish it with a few small shells collected from my beach walks. I want to show you how you can use a range of natural elements for inspiration.

Loom weaving

Looms form the foundation for weaving a flat piece of cloth or creative textures. You can use shop-bought looms to create a woven collage or you can make your own using recycled elements such as cardboard or a scrap of wood. Find out which you prefer to work on. I love using anything with a wooden vibe but I equally enjoy working on a foundation made from organic elements. You can then experiment with as many or as few ingredients as you like.

Natural weaving

Weaving with natural elements is an ancient skill and a wonderful way to connect with Mother Earth. I like to weave with all kinds of different ingredients, simply to experiment and explore their properties and create patterns.

I would need a whole book to cover this area of weaving as it is so inspirational, but for now, I've kept it very simple and restricted it to a few easy examples I've created after a lovely walk…

Different styles of looms for creative textile pieces

Four sticks tied in a square with weft threads.

Cardboard mini loom, using jute string.

From left to right: weaving with Fen sedge reeds and willow; weaving with beach grass; weaving with day lilies.

Circular weaving

Another way of creating a woven collage is with an embroidery hoop. The hoop can be any size, new or old and you can use it singly or as a double as you would when stitching. There are no rules. If you can find old hoops in charity shops or thrift stores, they often have a gorgeous natural patina and a 'pre-loved' story attached to them.

You will need some wool, yarn or string to create the warp threads. These form the foundation to your design. You can then weave with any other colour to create your weft threads. In the steps opposite you can see I have used green cotton yarn for my foundation base and completed the weaving with some blue and red wool.

TIP

You don't need to use the whole embroidery hoop, but if you want to frame your work you can add the second hoop on to secure the string in place. You can do this instead of adding in the weaving.

Circular weaving with a willow wreath.

38 Connecting with Nature

Step 1
Tie your string onto your embroidery hoop and wrap the string or yarn around in a circular rhythm like a bicycle wheel with spokes. When you feel you have enough 'spokes' to use, simply tie off with a double knot.

Step 2
Thread your wool through a wool needle. Tie the end of the wool onto a spoke in the centre and weave in and out through the spokes in a circular motion, working anticlockwise. I weave through both layers of spokes at the same time so that the pattern shows on the front and back of the piece. Continue weaving over and under until you have finished the first round. Repeat, making sure you alternate your unders and overs to create a woven pattern. It will take two or three rounds for it to settle into a rhythm. Continue until you have finished with your first colour.

Step 3
At the end of each round, neaten your woven stitches with the needle to give more definition to your shape. Don't worry about the regularity of your weaving. Any little blips will emerge into a lovely collage of textures.

Step 4
Repeat with as many colours as you wish to form a design. This is a slow process, so don't rush.

TIP
If you wish to add any natural ingredients into your design such as willow stems, simply weave them in and out of the woollen spokes by hand. Handle your weaving carefully to avoid broken stems!

Stick weaving

Here is a very simple way of getting started with just two sticks, perhaps collected from a walk.

Step 1
Bind the two sticks together with some string or natural twine.

Step 2
Choose a length of wool approximately 60cm (23½in). Tie the wool to the bottom stick as shown, using a double knot to secure.

Step 3
Holding your stick firmly in your left hand, wrap the wool around the right horizontal stick away from you in an 'over' motion.

Step 4
Turn your stick 90 degrees clockwise, then repeat step 3.

Step 5
Continue turning and wrapping until you have a rhythm. This will create a gentle weaving that you can make with any size stick.

40 Connecting with Nature

Driftwood from a beach in Norfolk.

Variegated silk wool.

Using Fen sedge reed to experiment with multiple sticks.

Examples of stick weaving
You may want to play and experiment with variations of under and over wraps to create different options of this design as shown here.

41

Slow stitching

Slow stitching is my absolute passion. As many of my loyal readers know, I love working with cloth and thread. Cloth combined with vintage or natural treasures creates a gorgeous fusion, especially when a little sewing is thrown in for good measure.

I have been slow stitching for most of my life, except I didn't always know it had a name! It forms the foundation to all my work even when combining it with all of the techniques shown in this book. You can slow stitch on a piece of eco-dyed cotton cloth, or on a shop-bought fat quarter. You can stitch on a woven piece of cloth you have created, or on a piece of bought calico.

For me, slow stitching is meditative, relaxing and gentle. It allows your mind to wander freely, switch off from the stress of daily worries and builds your confidence in choosing colours, patterns and designs because you are in charge of your end result. It is any form of stitching that allows you to take a moment out of your busy schedule to sit and focus on watching the beautiful alchemy of a needle sewing through a piece of cloth and working on a design that has no rules, no instructions to follow and no expected outcome. It helps still your mind.

Being yourself

Slow stitching is not the same as sewing a cushion or following a dressmaking pattern where you know what you are heading towards. Usually slow stitching is done by hand. It can be an embroidery or perhaps a tapestry, but I also like to include free-motion embroidery, which uses a sewing machine. Not everyone can hand stitch comfortably for reasons of health, mobility, dexterity, sight impairment or simply a lack of confidence, yet many can create amazing designs using a sewing machine.

In my 40 years of teaching students of varying abilities, I have learnt to adapt many crafts, projects and instructions to accommodate students who were unable to produce fine embroidered stitching, or make projects requiring exact precision or production in a certain size.

As a result, I always encourage people to find their own way, discover what works for their abilities and create something that gives them confidence and allows a freer outcome.

Accessibility has always been at the forefront of my teaching and if a sewing machine allows more creativity than your unwilling stitchy fingers do, then why not use it to help you develop your love of creativity?

Below are a few examples of my style of slow stitching. I hope they inspire you to experiment...

A collection of vintage and antique ingredients, hand-stitched onto a piece of early Victorian bed quilt. I will probably add it into a larger project and create a pocket for collected memorabilia such as letters and postcards.

Below you can see I have printed onto cotton some photos that I have taken on my walks, and added them into a textile wrap. I have embellished my design with free-motion embroidery and added in some natural elements.

Textile collage

I'm often asked what textile collage or textile art actually is. As a mixed-media textile artist, I design, I dabble, I create and I mix anything and everything into the equation of creativity.

A slow-stitched collage is simply a collection of different textures selected for their beauty, their colour or their individuality. It includes surface stitching, adding in layers of texture, using a variety of media and exploring textural marks through paint, cloth and embellishments.

We use all our senses when we create, not just our eyes. If you can produce something with a tactile vibe and let everyone touch it, you will immediately see the smiles appear.

Anything can be used in a collage. You are the designer, so you are in charge of your design. It doesn't have to follow any rules and it doesn't have to make sense to others. Just enjoy the process of being creative.

You can use shop-bought pieces of cloth, paper or wood or collect your own using some of the inspiration in this book. The choice is yours.

Here are a few examples of textile collage to show you what I have created using a mixture of natural ingredients on top of cloth and thread.

A simple heart corsage brooch stitched with some pre-loved treasures from the Edwardian era representing a summer's garden.

A little free-motion embroidery on a recycled silk blouse with some hand embroidery, showcasing the beauty of the wild Fens in springtime.

*Capturing the arrival of autumn in a journal.
Found objects are stitched onto eco-dyed papers.*

Seasonal projects

In the following section, I have designed a collection of projects divided into four seasons, although you can create them around any season you like.

Each project encourages you to enjoy a little creativity using the lovely wild and natural inspiration you may discover while being outside in nature. I hope you have fun exploring!

WINTER

SPRING

SUMMER

AUTUMN

WINTER

A Little Hygge

Showcasing treasures

Hygge = finding happiness in the simple things in life.

This project introduces you to the concept of bringing a little of Mother Earth's beauty back home with you for inspiration – bringing the outside in. I love nothing more than collecting pockets full of 'loved' treasures on a walk or a day out with my family. If you are like me, you may enjoy displaying them, so I am going to share some ideas with you. You can then be creative in displaying your finds in a special place in your home, school, workplace or campervan as you continue to collect throughout the seasons.

This project is based on the school nature table you may remember from your childhood days. When my sons were growing up, we had a little corner on top of one of our bookcases that we called our Nature Corner, and it was allowed to get as dusty or as scruffy as time allowed with all the wonderful gems they collected from days out. Every school holiday we would look at all the items and check them over for mildew or mould, then give them a dust and replace with new objects or rotate old favourites from our special 'treasure box' we kept from our adventures outside. This meant that the boys were in control of what they had out on display and could choose to keep some of their favourites out all year. Any extras were stored safely in a cardboard box.

A Little Hygge 49

Hygge (pronounced 'hoo-ga') is the Nordic word for coziness, originating from the Old Norse language. Most people think hygge refers to being snuggled up in front of the fire with a warm blanket on a winter's day, but it encompasses much more than that.

For me, hygge describes not only a feeling of happiness and gentleness, but also a feeling of being at peace with the world, and a reminder of all those happy memories created with family and friends when contentment rules the hour.

Hygge enters all aspects of my life: at home, at work and especially when walking outside and chatting to Mother Earth, whether that is on the beach, in the park, in the woods or along a riverbank.

Allowing yourself a physical 'hygge' space to bring a little of the joyous outside in will remind you of how you felt while out walking and make you feel more connected to all those beautiful gentle moments.

You'll be able to remember where you were at the time you found the items, what happened that day, what was going on in the world perhaps, whether it was a special occasion such as a birthday outing or simply whether the sun was shining.

I've already mentioned that we used the top of a bookcase, but you may prefer to set up a special corner on a shelf or cabinet devoted to your found curiosities. If you don't have a large space, you can of course use a tea tray.

GATHERING

We are gatherers,

The ones who pick up sticks and stones

And old wasp's nests fallen by the door of the barn,

Walnuts with holes that look like eyes of owls,

Bits of shells not whole but lovely in their brokenness,

We are the ones who bring home empty eggs of birds

And place them on a small glass shelf to keep for what?

How long?

It matters not.

What matters is the gathering,

The pockets filled with remnants of a day evaporated,
the traces of a certain memory, a lingering smell,

A smile that came with that shell.

Nina Bagley

A Little Hygge 51

WINTER

Treasured Memories
Memory sticks

This activity is an easy introduction to collecting natural elements and looking at them as keepsakes or treasures. It is a wonderful prompt to start off your year with a happy smile, beginning in the wintery months of January and February when the ground is icy and barren, Mother Earth is enjoying a quiet slumber, and you are nestled by the fire keeping those toes warm after a long walk.

This project features a selection of carefully chosen sticks that collect stories and smiles from days out with family or friends, or they can be something you create by yourself on a monthly basis.

Collect sticks from strolls outside, from your garden or, if you are unable to get out yourself, perhaps you could ask a neighbour to collect some for you. You may like to gather your sticks from the same tree or create a collection of different species. They don't have to be large, so little twigs will work if you prefer a mini version of the project. I like to add all kinds of different elements on mine as each month evolves. There are no rules, remember.

Treasured Memories 53

As a wild wanderer who loves visiting ancient woodlands and strolling through wetlands, I'm constantly looking around me for inspiration.

One of my favourite things to collect are sticks and twigs. I collect them all the time! Long straight narrow ones, curly wurly bent ones, wiggly misshapen ones and even ones laden with lichen and moss.

How often have you picked up a particular stick from a woodland walk and taken it home as a lovely reminder of a beautiful day out?

I call my found sticks 'memory sticks', because there is always a memory or two attached to each one. It prompts me to remember where I found it, who collected it, why I chose that particular stick and – if I know – which tree it came from. They are also known as 'journey sticks', 'story sticks', 'diary sticks' and 'nature sticks'.

THE HISTORY OF MEMORY STICKS

In ancient cultures, sticks performed the role of a diary, capturing a moment in time. They were also kept as travelling companions and helped carry bundles of herbs and food.

Long before maps were used, the Aboriginal tribes created journey sticks to record their routes and discoveries. By collecting objects and attaching them to the stick in chronological order, sticks became visual memory maps to recount a well-travelled journey to family and friends. These were a vital form of communication between people.

As well as a storytelling aide, memory sticks are also mementoes from travels or significant excursions, for example, a nature walk in an ancient woodland, along a riverbank, down a secluded countryside lane, or a visit to someone's garden.

You can add natural treasures to them that were found along the way. These might be leaves, twigs, flowers or feathers.

Creating a memory stick

How do you create a memory stick? There are no rules, and it is your own story. First, find a stick to start your collection. New Year is a good starting point, but you can of course begin your collection any time of the year. I like to add colour to my dry stick using an earthy palette, but you may prefer a brighter pop of colour. I usually start by selecting a few colours so I am not overwhelmed with choice. It gives me the option to include more later if I wish.

Step 1

Check that your stick it is not covered in creepy crawlies! Also make sure it is free from anything that is unhealthy for you, especially if you have found it where dogs love to roam. Your stick should be dry and free from mould, mildew or rotting debris. Next, I want you to get to know your stick. Look at her bark, her curves and her shape. She has a soul and a story. Withered and bent or straight and luscious, it really doesn't matter. Take time to notice all her little quirks.

Step 2

Decorate your stick throughout January... Think of colours you may like to use. What does January mean to you? If you live in the northern hemisphere, you may associate blues and whites as your main theme but if you live in the southern part of our world you may think in terms of a more colourful palette.

I start with a long length of wool, twine or thread to gently wrap around the stick. There are no limitations on how much of the stick you cover, how much wool you use or what extras you should add onto your stick.

Treasured Memories 55

Decorating your stick

It's up to you how many ingredients you choose to decorate your stick with. You may want to keep things simple and just wrap lengths of wool around your stick to create a collection of rainbow sticks or you may represent a complete woodland using all the elements you discover along the way! Either way you'll portray something unique and beautiful, filled with memories known only to you.

I like to tie on the lovely treasures I have collected such as feathers, little twigs, cones and leaves. You can add buttons, embellishments, beads, ribbons, grasses, natural twine and pieces of bark if you wish.

Suggested ingredients to include

- *Wool * string * ribbon * lace * strips of cloth * raffia * ribbon trim*
- *Buttons * beads * broken jewellery*
- *Feathers * leaves * nut shells * dried grasses*
- *Pine cones * small twiglets * dried flowers * seedpods*
- *Shells * dried seaweed * pebbles * sea glass*
- *Stamps * train tickets * bus tickets * labels*

Think outside the box... For example, if you venture to the post office on your walk, add in a stamp. Make your stick tell your own story.

STICKS I LIKE TO USE

Did you know a stick is not 'just a stick'? Each one is unique and has its own story. It holds its own secrets from the tree before it has even fallen. And each has its own patination, marks and individual identity. Some of my favourites are:

Ash * Oak * Elder * Silver birch * Sweet chestnut * Lime * Alder * Horse chestnut * Beech * Sycamore * Willow * Hazel * Cherry

Here I have created a memory of Yuletide using a few handmade decorations and textured yarns in colours to match.

56 Connecting with Nature

A calendar of sticks

You can either make your memory stick as you walk or collect the ingredients while out walking and then create it at home. Display your stick in a vintage vase or an old bottle, or even add it to a wall hanging. Be creative!

Start each month with a new stick regardless of whether you finished the previous month's stick. You are building a visual diary of memories, not writing a novel, so it doesn't have to be complete, or perfect. Some sticks may only use a few items, while others might be completely full of decoration.

TIP

You may wish to add a label to each stick with thoughts from that month or dates and times of where you visited, and so on.

Memory sticks through the seasons

Winter walks with my grandson

I created this memory stick after a lovely walk in our local park with my grandson, Harry. He chose the sticks and we created it together when we got home. We had great fun wrapping a mixture of white and grey woollen yarns around our sticks. Harry wanted to keep the sticks together, so I suggested we could add the blue yarn (his favourite colour) and let the sticks hold hands too! Allow your sticks to tell your story... It's a lovely way to share stories together and talk about special memories. Harry chose a small jam jar to keep the sticks in.

Winter

Winter collection of sticks: December, January and February.

Spring

Spring collection of sticks: March, April and May. The April stick has a smaller version, made by my grandson, Jaxson. We made them together at the coast.

Summer

In my summer collection of sticks, I've chosen colours that represent the month as I create them. For me, June offers afternoon teas in old-fashioned cottage gardens full of roses. I love the gentleness of their blooms.

July offers trips to the Norfolk coast, ice creams and sandy toes.

August is often too intense in heat for me, so I seek out the coolness of a wooded walk for a little shade. It also offers a glimpse of autumn waiting to say hello in the near future!

Summer lavender

The example below is the 'Lavender ladies who lunch' memory stick I created while walking with two dear friends, Bron and Mel.

After sharing a delicious lunch together at Norfolk Lavender we went foraging around the gardens for some snippets. We all took our baskets to collect some found treasures and came away delighted with our finds. Such a beautiful day full of memories.

I wound some vintage lavender tapestry wool around my stick to represent the lavender fields. I then wrapped a few ribbons of lily leaves around. They were a vibrant zesty lime green and yellow stripe when I picked them, but they have sadly dulled over time and now offer a banana hue; but they are still beautiful…

I added on the other ingredients that I found while walking – dried lavender stalks, a pheasant's feather, dried silver birch bark, white willow leaves, a sprig of cypress and a dried sprig of box from the formal lavender garden. I've only used naturals to create my stick – no plastic, no sticky tape nor anything synthetic.

It has sat on my kitchen dresser since my return home and reminds me of the beautiful time we spent together, giggling and smiling under the warm Norfolk skies.

It's not just a stick, it is a golden memory of a day to be treasured, a tactile diary of our day, a unique story, our little secret…

Autumn

Autumn collection of sticks: September, October and November. The cooler months of autumn offer a different colour palette. Here I've shown how you can keep your sticks quite simple if you wish by just using wool wrapped around. Be as creative as you fancy.

Dogwood stems in autumn

In this slow-stitched nature wrap you can see I've attached some dogwood stems that I found on a winter walk by oversewing them onto the cloth using a cotton perle thread. Sticks work really well as spines for journals or books.

I love the contrast in colour. The red wood seems to shine brighter in the winter sunshine. Maybe it's a way of telling us to be patient; brighter days are on their way...

Treasured Memories 61

WINTER

A Walk with Flora
Botanical journal

A journal is something you can dip into now and then when the mood suits, unlike a diary that has to be written chronologically.

In this project I hope to encourage you to start your own botanical journal as a keepsake. In it, you can capture your own beautiful memories and thoughts on natural shapes, colours, textures, folklore history of plants, leaves and herbs, and any observations you make as the seasons change throughout the year. You can showcase your collected treasures from your walks, write down snippets of information you discover along the way, and add in little extras to your journal.

I also hope to encourage those of you who feel there has to be a purpose to go for a walk to just venture outside for the sake of it. If you are unable to get outside due to mobility or mental health issues you may prefer to just focus your journal on your view from your window, perhaps throughout the seasons.

Either way, the important thing to remember is this project encourages you to slow down and take some mindful moments every now and then, to appreciate the world around you as the seasons come and go, and to use your journal as inspiration for other projects.

A Walk with Flora 63

A few rules (that aren't really rules!):
- You don't have to write in your book every day.
- It doesn't have to be perfect.
- It doesn't have to look neat.
- Most importantly, it doesn't have to make sense to anyone but you. It is your journal, so make it your own!

Making a start

To get started, I suggest you treat yourself to a lovely notebook that you don't mind taking with you on walks. You may wish to keep a neater version at home. I find a hardback book easier to write on because it provides a firm surface when notetaking out and about.

It doesn't matter what kind of pages your notebook has. Some people prefer a lined notebook; others prefer an empty page to sketch upon. I like to use plain paper because I doodle so much.

My favourite paper is Indian rag paper as it is so soft. Artist's cartridge paper is another favourite. I collect lot of treasures as I walk, and tape or glue them in my journal. I may even stitch them in if they are quite bulky.

I started my botanical journal on New Year's Day simply because we went for a beautiful meander outside after the festive activities. I wanted to start my journal on a positive vibe at the beginning of a new year, but you can start your journal on any date, any day and in any season.

For this project, I used a shop-bought journal from India that offered pages of paper, card and cloth, but you may wish to create your own book using some of the methods shown in this book or purchase a plain notebook and stick in a few different papers to get started. My book had a hardback cover with plain pages that I could paint, stitch, dye and draw on.

If you dread the idea of working on stark white or plain natural pages, you can colour or paint your pages with different pens, paints or pencils.

Making flexible plans

I started by writing a list of some of the things I wanted to capture in my journal, but I also knew serendipity would soon drop by and I would change the ideas as the journal evolved throughout the year. Allow yourself permission to change your plan as many times as you fancy. Don't restrict your goals otherwise you will feel you've failed but you will actually have unleashed your creative thoughts in a wonderfully gentle way!

My plan included:
- adding many found treasures, discovered on my walks
- finding out the names of plants, trees and insects I was unsure of
- capturing memories with dates and names of places
- discovering new locations.

Adding to your journal

As the months rolled on, I started to write, draw, doodle and glue in found objects. I didn't write in my journal every day, sometimes weeks went by, but I tried to add something each month. Below and overleaf are some of the pages of my journal that I hope will inspire you in creating your own.

Found and treasured items

A few extras to include in your journals:
- dried leaves, grasses, petals and herbs
- twigs
- drawn patterns taken from observations
- photos of places you've visited with dates and names
- postcards from visits
- nature poems and quotes.

I created the background of this journal page with a combination of watercolour paints and a herbal dye. I used a butterfly rubber stamp on my painted page, then added my own writing. I took inspiration from watching butterflies dance in the Fenland wildflower meadows and gave my own butterflies a gentle brush of colour from an onion skin dye.

66 Connecting with Nature

Look carefully...

Take your time to look carefully at what you can see in front of you. I love capturing the different tones of Mother Earth in watercolour and pen marks. If you spend a little time observing leaves in different seasons you learn to see the beautiful rainbow of shades on offer.

Below I've used eco-dyed paints created from natural tree barks.

A Walk with Flora 67

You can see how the pages vary. Some hold facts that I've unearthed; some are simply pressed flowers and a few doodles. Remember your journal is yours, not mine. There are no rules about what to add. It has to make sense to you, and you need to feel connected to it. As your journal evolves, I know your connection to Mother Earth will deepen. You will find you stop and stare at things much more to look at the tiny details. You will perhaps jot down the moon cycles or keep a record of the plants in your garden each month.

Your journal will not only capture a moment in time but will also turn into a record of social history in a botanical way. Have fun – it doesn't have to be a serious diary. Simply use it as an encouraging way to discover a little more about the natural world around you.

Capturing a little of midsummer.

Showcasing Mother Earth's beauty.

'Gentleness'

I created this wall hanging for a workshop, using notes from my journals. I wanted to showcase how you can mix, stitch and create with cloth and paper. My finished piece captures how the gentleness of a walk in the garden can bring you so much joy. My inspiration came from Barnsdale Gardens in Rutland, created by Geoff Hamilton in the 1980s for the the BBC's Gardeners' World series.

Here, I captured the magic found in a local ancient woodland. I loved the mystery of the quietness!

I drew this page after a visit to the beach at Old Hunstanton, Norfolk in the midst of a July heatwave. It is one of my favourite beaches.

70 Connecting with Nature

As my journal evolved, I created a journal cover from a piece of embroidered linen I had in my stash, simply by wrapping it gently around the book. You can see I have sewn on some of my found twigs and woven willow to form a textured spine.

A Walk with Flora

SPRING

Patterns in Nature

Stitch diary

I wonder if the snow loves the trees and fields, that it kisses them so gently? And then it covers them up snug, you know, with a white quilt; and perhaps it says, 'Go to sleep, darlings, till the summer comes again.'

Lewis Carroll (1832–1898), *Alice's Adventures in Wonderland*

Spring is a beautiful time of year to appreciate the tiny details that appear as we venture from the gloomy days of winter and start looking forward to the warmer days of sunshine. Mother Earth is beginning to bloom again after her long slumber and there is an abundance of inspiration all around us as we start to notice the new plants, flowers and trees with their leaves starting to awaken.

Patterns in nature have fascinated me since I was a child and every new season brings new sights aplenty. I am always excited to see what the next venture will offer. Often this is the time of year when I like to start a new cloth stitch diary to record all the wonderful patterns and textures I come across on my travels.

I try and sketch or doodle while out and about, using a small notebook specifically dedicated to my new discoveries. Once at home, I take my time to transfer the patterns onto cloth in my stitch diary using hand sewing.

I like the gentleness of capturing the seasons and the fact that I can work at my own pace. I want to share a little secret here... sometimes I am so slow at sewing that my seasons get very out of date and you may find me stitching summer in winter or autumn leaves in January!

Patterns in Nature 73

For me, a stitch diary helps to connect the outside world with my textile world in a gentle, tactile way. I take inspiration from bark, flower shapes, ice patterns, leaf designs, petals, even marks left by wildlife on pathways. Once you start to observe the patterns found in nature, you'll find inspiration everywhere.

My favourite trees are silver birch. I collected some bark and used it as an inspiration for sketching, then stitching.

Kantha stitch

My stitch diary uses only a type of running stitch called a Kantha stitch to create the textures. It is an easy way of using a single stitch but different threads to create the patterns. I hope you will be inspired to give it a go and create your own version. Kantha stitching is a very slow, meditative process which originates from India. Traditionally, it was a form of stitching used to patchwork small pieces of saved cloth scraps together to create a completely new cloth.

During my visit to Jaipur, India in 2020, I loved seeing Kantha stitching used in a very decorative way other then patchwork, and I have been inspired to include it in my stitch diary.

Remember your stitch diary is only the starting point. Once completed it is something you can refer back to again and again or just use it as a project in itself. Think about how your stitched patterns can be used. Can they be used in a project? If so, what kind: a slow-stitched collage? Dressmaking? Free-motion embroidery? Patchwork quilt? When looking at a natural resource for inspiration, ask yourself what direction the stripes are going in and if it is a circular pattern.

Kantha stitch.

You can see how I've created circles with Kantha stitches to form the diary cover. I was inspired by puddles.

This is a piece of Kantha work I brought back home with me from Jaipur, India. The cloth was block printed first, then stitched with thick cotton thread.

Materials...

6 pieces of calico, 21 x 30cm (8¼ x 11¾in)

3 pieces of deluxe interlining, 21 x 30cm (8¼ x 11¾in)

Selection of threads

Sewing needle

Ribbon to tie together (optional)

Creating a stitch diary

Step 1
Lay a piece of deluxe interlining between two pieces of calico to create a 'cloth sandwich' which will become your page.

Step 2
Sew a running stitch all the way round to secure the edges of your sandwich.

Step 3
Repeat steps 1 and 2 until you have enough pages. Layer your pages on top of each other.

Step 4
Tie a ribbon around to finish. I am using an outer cover on mine.

Step 5
Start stitching onto small pieces of cut calico with your designs, ready to add onto each page. Experienced sewers may prefer to sew directly into the diary. Here you can see I've used Kantha stitch with different thickness threads.

Patterns in Nature 77

SPRING

Dancing Ballerinas
Nature mandala

I often create mandala designs quite randomly while out walking along a woodland path or a country lane. Sometimes I use just a few items that catch my eye such as a posy of wildflowers mixed with a few sticks. Other times I forage specifically for items, allowing myself some stolen moments to create something a bit more detailed. I absorb the slow pace and treasure it.

It upsets me that I can't take my designs home, but on a positive note, I'm leaving a little surprise nestling among the greenery ready for the next visitor who passes by. Once I have completed a mandala and am happy with my overall finished design, I take plenty of photographs as a reminder for when I get home, then try and doodle a few sketches based on my design.

I like to use my mandala designs as inspiration to create a stitched design, a textile collage or sometimes an addition to a fabric design.

Dancing Ballerinas 79

Creating a nature mandala

If you are not familiar with the word mandala, it means 'circle' in the ancient Sanskrit language of Hinduism and Buddhism. Mandalas are symmetrical, circular, geometric patterns, first created by Buddhist monks in the Himalayas some 2,000 years ago.

A nature mandala is a beautiful, spiritual and simple way to explore nature creatively as you meander through the countryside, woodland or your garden. There are no rules whatsoever, so it is a gentle introduction to pattern, colour and seasonal delights. It is just a matter of playing with your ideas.

I have been creating nature mandalas since I was a child. I've always loved making collages with natural elements found on walks. I was also fascinated by patterns found in nature and would make 'pattern circles' with my twigs, petals and other found items. I loved making twig wheels in the autumn from the smaller twigs that fell from the branches on windier days. I collected them up, along with conkers and pine cones to create circles, a little like bicycle wheels with twig spokes.

I love nothing more than taking an hour or so to collect various resources I see around me, then simply enjoying the creative process of fiddling and faffing!

In technical terms it means you are allowing your brain time to daydream and create, but I'm sure most people relate more to that beautiful pastime of fiddling and faffing!

The slowness of exploring ideas is beneficial in so many ways. It helps to ground you, takes you out of your busyness and gives you a deeper appreciation of and connection to Mother Earth.

I created this simple floral mandala using the table top of a bistro set as its background. The leaves and flowers are from a mock orange shrub (philadelphus) from my friend's garden.

80 Connecting with Nature

Below are some examples of mandalas I created while on holiday in Penwith, Cornwall. I was mesmerized with the gorgeous beauty of the fragile fallen petals of the rhododendron and camellias and wanted to capture a little of their beauty in these floral displays.

Dancing Ballerinas 81

Using a mixture of young and old blooms can create a beautiful blend of shared secrets.

Engaging your senses

When creating a mandala, you will use your senses in a much more tactile way, smelling petals, touching bark, feeling the earth under your fingers as you lay your pieces down.

It may only be a fleeting moment in time you are able to capture, but it will help you have a better understanding of the season you are in, the time of day you collected the ingredients, and how the environment feels around you, all of which are positives in my mind.

Introduce the activity to your family and enjoy some downtime exploring what's around you...

Allowing yourself time to enjoy creating

My 'Dancing ballerinas' project is based on some lovely mandalas I created with my friend Bron in her beautiful wildflower garden nestling in the north Norfolk sunshine.

We had set aside a whole afternoon for ourselves, creating with nothing more than fallen petals, leaves and twigs. The mindful slowness of walking around noticing the different flowers and collecting them in our baskets was just as important as the process of creating our mandalas.

We took our time, often stopping for a cup of tea, and when we finally decided we had collected enough to play with, we started to slowly add them together. This part of the process is often the longest while you decide what colours go well together, what shapes the petals or leaves can create and how repeating patterns can evolve into something so gentle.

I took many photographs as a reminder of our beautiful day together as I wanted them to inspire a stitched piece as a keepsake. The other happy part for me was the discussion about wildflower names, sharing our love of folklore history and how we connect to the seasons.

I have called the project 'Dancing ballerinas', because I love the fluidity of the meandering fronds I created. The way the bluebell is positioned makes her look like a graceful dancer.

Dancing Ballerinas 83

Developing your designs

I want to share with you how I develop my designs, and
I hope it will inspire you to try and create something similar.

Step 1

After making the natural mandalas and photographing them, I sketched a few doodles from my photographs. The drawing then becomes my starting point for a little slow stitching I would like to do with my design.

Step 2

I used an old cotton pillowcase as the foundation cloth to stitch on, but felt it was a little dull through years of constant washing. It needed something to lift the background. I decided to dip it in some dried nettle dye to gently add a background water wash.

I used a soft pencil to sketch my drawing onto the cloth freehand, adding the ballerina in the centre. You can see I've created her with a flower, heart petals and a folded rose flower for her twirly skirt which I've accentuated by adding some extended lines.

Sketch lightly in pencil.

Step 3

I've also creatively added a headdress using a stem of a bluebell as the inspiration. I used a split stem stitch and hand-dyed threads.

I started outlining the hearts using a stem stitch with a thicker perle cotton thread to give them a little more prominence in the design. I then used a felt tip brush pen to sketch on top of the pencil lines to add an extra depth to my embroidery.

Stitching hearts with stem stitch.

Stitching the headdress.

I used a finer thread and a split stem stitch to add extra texture to the headdress. I often find a stem stitch can 'topple' over at times so I like to use a split stem stitch. By splitting each individual stitch, it allows my threads to be a little more secure with some extra anchoring.

When I started, I had no idea how my design would look, so I added the details very slowly. I have deliberately left this project unfinished because I feel it is important to show the design process. You can see the faint outline of the camellias still to be drawn.

I may turn my finished design into a small wall hanging or add it to a plain canvas shopper bag which I will choose once I'm finished.

I hope this project has inspired you to try and create your own version of a nature mandala.

SUMMER

Seascapes
Woven collage

Delight in the little things...
Rudyard Kipling (1865–1936)

I absolutely love visiting the beach and watching the waves roll in. A stroll in the ebb of the tide is sufficient to quell a frazzled mind any time of the day. It is my form of gentleness and recuperation.

I'm lucky to have a little vintage caravan nestling in a quiet village in north Norfolk, where I have taken my inspiration for this project. The beach there provides a gorgeous sea-escape for me, hence the title 'Seascapes'.

This project involves weaving onto recycled card using cloth ribbons, yarn and string. It is a gentle project that the whole family can get involved in or it can be a project you treat yourself to when you visit the beach throughout the balmy months of simmering heat.

Seascapes 89

Decide on the size of your project before you start. You will need a piece of cardboard to create a loom to weave with. I like to use flat pieces of cardboard packaging rescued from online deliveries to prevent them ending up in landfill, but you can use shop-bought cardboard if you prefer. Remember, it needs to be sturdy enough to handle the weight of all your weaving.

> **TIP**
> Warp and weft threads create the basis to any woven foundation. Warp threads are the 'verticals' and weft threads form the 'horizontals'.

Creating a loom

I am using a 15 x 22cm (6 x 8½in) piece of card to demonstrate the technique, but you can see that I have created a larger version for the project, using a selection of wool and cotton yarn to allow for all my shells and extras.

Step 1
Mark regular lines where the slits will be. Cut slits in the top and bottom of each end of your card over the pencil marks. This will allow your string to sit comfortably on your card while you weave.

Step 2
Start with a long length of string to create your loom warp threads. Use masking tape or sticky tape to secure the end of your string onto the card at the back.

Step 3
Wrap the string around the card from top to bottom using your slits as a guide. Make sure each one is used. The string should have tension so that your weaving is flat, but don't pull it too tightly otherwise the cardboard will bend. Finish off with another taped end at the back of your card.

Weaving

To help me visualize the end result, I lay out the ribbons and wool in the order they will be used.

Step 1
Knot your string or yarn onto the outer warp thread. (You won't need to do this if using ribbon.) This can be left for extra texture or woven into the project. Use your first string for your weft lines and weave it across in rows from right to left, then left to right. I am creating a basket weave by going over and under each thread.

Step 2
When you have used all of your string, simply add in another piece of cloth or ribbon. You might want to experiment and vary your up and over from one piece of ribbon to the next, to give extra patterns.

Step 3
Push your work down slightly after a few rows so gaps don't appear in your woven cloth.

TIPS
- You can weave in straight rows across or mix and match with shorter pieces of ribbon to create an uneven mix of woven 'threads'.
- Try adding a twist to your ribbon every now and again, to create more texture.

Step 4
Keep building your weaving, a little at a time. This is a slow process, something to enjoy and not to endure. Take your time feeling the ribbons nestle in place.

Step 5
I leave knotted ends as an extra feature in my woven collages, but if you prefer a neater finish then use a needle to weave the ends into your work when you have finished the whole design.

Seascapes 91

Removing weaving from the loom

Step 1
To remove your weaving from the cardboard loom, first remove the masking tape from the back of the work. Using a pair of sharp scissors, snip across the centre of the threads.

Step 2
Pressing lightly on the back of the cardboard, remove the string strands very carefully from the slits of the loom.

Step 3
Tie the string in pairs using a double knot.

TIP
To add extra flavour to your designs, why not incorporate some natural embellishments of dried sea grasses, shells and found objects?

You can use your woven collage for multiple purposes. I have added mine onto a journal cover.

Variations of woven collages

Wool, cloth and ribbon are all suitable for weaving into a collage, and provide a good base if you wish to add something extra on top, such as embroidery, found treasures or other embellishments.

I've used a variety of threads and wool to create a textured collage which is now ready for slow stitching a wildflower meadow.

'Inspired by the sea'

This piece will become a journal cover for capturing memories throughout the summer.

Seascapes 93

SUMMER

The Language of Flowers

Mini flower press

*But just to keep alive is not enough.
To live you must have sunshine and freedom,
and a little flower to love.*

Hans Christian Andersen (1805–1875)

In the summer months, when the gorgeous wildflowers and garden blooms are aplenty, I love collecting a few of my all-time favourite flowers and pressing them ready for adding into journals or other craft projects.

Many memories can be captured and treasured by keeping a handful of blooms from day trips or a few florals from your garden that made you smile. Perhaps you've had a rogue visitor to your garden such as a wild poppy and want to capture her beauty as a wonderful reminder of her visit.

One of the easiest ways of keeping petals safe is to press them for future use until you can transfer them into something more permanent as a keepsake. I'm often asked how to do that while out walking, especially if you are away from home for a few days. I agree that it is impractical to carry around a traditional flower press, so I devised my own little flower chapbook that solves this problem. It is invaluable for preserving and pressing petals or leaves while out and about, as well as for keeping notes or doodles.

The paperclips add extra security to make sure your saved florals don't move about or even fall out of your mini press as you stroll.

The Language of Flowers 95

Chapbooks are the perfect size to slot into a pocket of a dress or trousers, easily nestle inside a backpack or if, like me, you always take a special 'walking bag' with you, you can adapt your flower press to the correct measurement to fit.

Since your chapbook pages are interchangeable, you can add or take away your finds as you build up your collection. The cotton rag paper is strong enough to give a gentle support while the pressed flowers are flattened, yet soft enough to allow the petals to nestle into the paper without damaging them.

Don't feel you need to go out and buy special paper. There are several different papers you can use, many of which you may already have at home. They could be postcards, greetings cards, or tissue paper stuck onto cardboard.

PAPERS I LIKE TO USE

Card * printer paper * handmade paper * pressed flower paper * wallpapers * old magazines * old birthday cards * recycled packaging * newspapers * sugar paper * cartridge papers * Khadi rag papers * painted papers * silk paper

As well as flower presses, chapbooks make excellent journals, diaries, sketchbooks or a place for collecting natural ingredients.

The Language of Flowers 97

Creating a mini flower press

I have listed the size of paper I used, but the size doesn't really matter so long as all the pages are roughly the same size.

I have made a cover for my flower press using calico painted with blackberry dye and stuck it onto a piece of card slightly larger than my folded pages.

Materials...

4 sheets of Indian Khadi paper or rag paper, 15 x 21cm (6 x 8¼in)

Paperclips (I suggest at least ten)

Pencil or pen for writing notes

Ribbon for tying your book together. I've used sari ribbon

Step 1
Lay your sheets of paper flat, in a pile. Decide which order you want them in, especially if you are using different papers.

Step 2
Fold the pages in half and loosely mark the crease of your fold line by running your finger along the folded edge. You can make this as crisp as you wish but I generally leave mine quite softly folded.

You can fold up to five sheets comfortably if using printer paper, but a heavier paper will be thicker, so only tackle a couple of sheets at a time.

Step 3
Place your folded papers together to form a 'booklet'. Tie a ribbon around the centre to secure the pages a little more from moving around. I like to tie a bow in mine for prettiness but you may want to leave yours with a simple tie especially if you are using it as a travel press on your holidays. You may need to adjust the ribbon slightly once you start to fill your flower press to allow for petals, grasses or leaves.

Step 4
Pair your pages and add paperclips around the edge of the pairs to create pockets that will securely hold your flowers.

TIP
I prefer to tie my papers together rather than stitch them as I feel it allows much more flexibility with adding resources. I usually use something like a jute string or sari ribbon as a tie, but you can use anything that takes your fancy. Be as creative as you wish... wool, string, raffia, eco-handcrafted string from plants, cotton rope, embroidery threads, hand-spun twine.

3

4

Further inspiration

Here are some examples of chapbooks created using cards. Whether you use handmade or shop-bought cards, this is a lovely way to recycle treasured cards into a new keepsake.

Choosing flowers to press

I like to pick my flowers after the morning dew has dried but before the raging afternoon sun dries away their natural oils. If you leave it until after sunset, you may find it difficult with some petals as they start to curl a little in readiness for their bedtime nap!

TIP
Make sure your flower is dry before pressing as you may end up with a mouldy smudge on your page!

102 Connecting with Nature

The language of flowers

Floriography is more commonly known as the 'language of flowers' and has been practised for thousands of years across different cultures. The language of flowers was very popular in Britain during the Victorian era when learning the symbolism behind each flower became a hobby. It was used as a means of coded communication, allowing people to express feelings which otherwise could not be spoken.

Below are a few of my favourites...

Aster – love and daintiness
Bluebell – humility and constancy
Buttercup – childishness
Calendula – considered sacred
Carnation – woman's love
Carnation (pink) – I'll never forget you
Celandine – joy
Chrysanthemum – cheerfulness
Chrysanthemum (red) – I love you
Coreopsis – always cheerful
Cornflower – purity
Cowslip – pensive, thoughtful
Daffodil – chivalry, respect, unrequited love
Daisy – cheerfulness
Everlasting sweet pea – wilt thou go with me?
Fern – fascination, sincerity and magic
Freesia – innocence
Hollyhock – fruitfulness
Hyacinth – playful, loveliness
Iris (yellow) – passion
Lavender – loyalty, love and devotion
Lily-of-the-valley – return of happiness
Love-in-a-mist – you puzzle me
Magnolia – love of nature
Mistletoe – kiss me
Pansy – thoughtful reflection
Primrose – I can't live without you
Queen Anne's lace – haven
Rose – love
Rosemary – remembrance
Shasta daisy – beauty
Sweet violet – hidden virtue and beauty
Tulip – love and passion

SUMMER

A Moment in Time

Sun printing

The joy of seeing a flower or plant bloom after having watched her grow is just beautiful. However, you know her visit is but for a fleeting moment, sometimes a week, a few days or even only a few hours.

But what if you were lucky enough to savour her beauty forever in a sun print? This project showcases how, combined with a little sunshine radiating through a sun print, your chosen plant can be captured as a wonderful moment in time.

Cyanotype, sometimes referred to as sun printing, is one of the oldest forms of capturing a moment in time on fabric or paper. Images are created by placing an object directly onto a special paper or treated cloth and exposing them to sunlight for a limited length of time. The objects placed on the paper or cloth block the sunlight and prevent the dye process from activating, leaving exposed white areas. These in turn become your finished images. The colours develop right in front of your eyes and are captivating to watch. As you can guess, I absolutely love the serendipity of this ancient art!

A Moment in Time 105

Materials...

A tray

A few laundry pegs, clothespins or paperclips

A sheet of pre-treated cyanotype fabric

Clip frame, larger than the fabric sheet

Creating a sun print

Step 1
Lay your flower or leaf onto your cyanotype sheet and cover with the clear acrylic sheet from your frame to flatten your flower. Peg or clip in place to prevent any movement. Lay your frame outside in the sunshine, away from any shadows, for 5–15 minutes following the manufacturer's instructions. The longer you leave your print, the stronger the result.

Step 2
The cyanotype cloth will turn white in the sun, except for the area covered by your flower or leaf which retains the blue.

TIP
I've used pre-treated cloth sheets which give me the option of sewing onto the sun print, but you may want to use pre-treated cyanotype paper instead. Both can be purchased online.

Step 3
Rinse the fabric under the tap or you can place it in a bowl of cold water. The blue areas will become white and the white areas will return to blue (cyan!).

106 Connecting with Nature

Step 4

Lay flat and allow to dry naturally. I usually leave mine on grass. If you are drying indoors, place the wet fabric on an old towel. Once dry, you can use it to stitch or paint onto, or leave as it is.

Step 5

I ironed my fabric flat and then stitched a sedge reed design using a cotton perle thread and a stem stitch.

A Moment in Time 107

Here is a selection of sun prints I created using found wildflowers and leaves from the Fens. For each, I used a pre-treated piece of cloth. You can see how I experimented with different exposures of time, creating varying tones of colour.

The history of sun printing

Cyanotype is an antique photographic printing process distinctive for producing Prussian blue monochromatic prints. It developed in the mid-nineteenth century as an inexpensive method of reproducing photographs, documents, maps and plans, hence the term 'blueprints'.

(Left) I created a shadow on this sun print by moving the fern halfway through the process. This gives the effect of a double exposure.

Sometimes, I turn the fabric over and use the reverse to stitch onto, as a feature. This results in a totally different appearance.

A Moment in Time 109

AUTUMN

Nature's Gems
Garland

I really wanted to include a mini project to celebrate my love of a garland and showcase Mother Earth's natural gems.

This is the perfect slow-stitched project for anyone wanting to add a little decoration to their seasonal display either in their hygge corner or on a dresser shelf.

It is a very gentle project that you can complete over a couple of evenings while watching TV, or take it with you on a weekend away. I have used an autumn design, but you can adapt this project for any season or celebration.

Nature's Gems 111

Creating a stitched garland

Materials...

Piece of cotton or linen to use for your garland squares

Selection of natural materials to add as extras, e.g. twigs, dried leaves

Selection of embroidery threads

A length of braid, trim or ribbon

Step 1

Cut squares from your chosen cloth. The size can be whatever you wish. My mini squares are approximately 10 x 10cm (4 x 4in). Choose a design for each square. You may wish to simply sew on natural elements and not actually embroider anything else. I'll leave that up to you to decide... I've added some toadstools, leaves and flowers to mine, but you could draw anything or even use an embroidery transfer.

Embellishments

If you wish to add more decoration, you could choose some of the following:

beads * buttons * sequins * diamante * gemstones * nuts * shells * appliqué flowers * dried petals

Step 2

Once you have completed each little square, assemble them along a length of braid, trim or ribbon. Simply pin in place and sew them on using a back stitch or running stitch.

112 Connecting with Nature

Nature's Gems 113

AUTUMN

Fallen Leaves

Artist's brush wrap

*Is not this a true autumn day?
Just the still melancholy that I love –
that makes life and nature harmonize.*

George Eliot (1819–1880), Letter to Miss Lewis, 1841

There is something exciting about capturing the textures and patterns given freely by Mother Earth and using them in your own creative way. Leaf prints are a perfect example. Leaves are one of the most popular natural ingredients to use as they are so readily available and easy to use.

We seem to notice their details much more in autumn as they twirl from their branches or we walk through piles of fallen leaves, often curled and a little worn.

I love to use them for leaf printing in so many different ways and it can become quite addictive once you get started! I've created this simple hand-stitched artist's brush wrap as a little project that will make a beautiful, personalized gift for yourself or for your creative friends!

This wrap project is perfect for keeping your paintbrushes safe, especially if working outside on a day out, but you can of course adapt the project to store crochet hooks, knitting needles or drawing pencils. Once you have your basic design, you just need to adapt the size to fit your preferred contents.

Fallen Leaves 115

Leaf printing

It is great fun experimenting with printing using a variety of leaves. Find out which shapes you prefer, which ones give you the best designs and which are easier to use.

Materials...

Piece of calico or cotton for leaf printing, approximately 35 x 50cm (14 x 20in), ironed

Selection of acrylic paints in different colours

Paintbrush, preferably a flat brush

Paper to practise leaf prints on

Selection of leaves – experiment with as many as you wish

Ribbon or lace, to tie

Suggested leaves to use

- *Large glossy – magnolia * laurel*
- *Large – horse chestnut * sweet chestnut*
- *Medium – sycamore * beech * elder*
- *Small – lemon balm * mint * rose * silver birch*
- *Decorative – acer * rowan * oak*

You can use dried leaves of course, but I prefer fresh if possible as they are more flexible and a little easier to print with.

Suggested fabric to use

*Cotton * linen * hemp linen * bamboo * silk * calico * polycotton * vintage tablecloth * vintage tea tray cloths * old bedding*

TIPS

- Don't overload your brush with paint and don't press too hard when printing!
- Do a test print on a scrap piece of paper to test how much pressure you need to apply. This will help you understand how getting an effective print is a gentle process.
- I always pack a metal camping mug when I go out and about. This reminds me to take water as well, for rinsing my paintbrushes.

116 Connecting with Nature

Step 1
Use a paintbrush to gently brush one side of one of your leaves with a small amount of undiluted acrylic paint.

Step 2
Gently press down onto the cloth and smooth over with your hand to make an imprint.

Step 3
Practise on your paper first then print several leaves onto both sides of your calico piece in random directions to create the illusion of a flurry of autumnal leaves. Be as creative as you dare!

Step 4
Build up your design using different-shaped leaves and a few paint colours. Allow the paint to dry before 'setting' the design by pressing with a hot iron (without steam). Once dry, turn over your fabric and repeat the printing process on the back.

Close-up detail.

TIP
If you prefer to use two different fabrics, you can use two pieces sewn together.

Fallen Leaves 117

Creating your brush wrap

I am using a vintage linen pillowcase that has been eco-dyed with red cabbage leaves in a simmer pot. It is 35 x 50cm (14 x 20in) and has been ironed. You can see I've chosen to leave my edges frayed but I know many people will find that too messy. Remember, it is your brush wrap not mine, so make your own preferred style.

Step 1
Double fold the top and bottom of the fabric, with the inside facing up. Secure with running stitch.

Step 2
Fold over the bottom of your cloth towards the middle. This will form your pockets. Lay your brushes on top of the folded cloth – the top of the pocket should sit at least three-quarters of the way up the brushes. Allow at least 3cm (1¼in) between each brush. Using a pencil, mark where your running stitches will go to form the pockets.

Step 3
Sew a line of running stitches between each brush through the folded cloth, using your pencil lines as a guide. Secure with a back stitch.

Step 4
Roll up your wrap and secure with a little ribbon or lace. Mine is a sari ribbon dyed with blackberries. You may wish to sew this in place on the edge of one of the sides, depending on which way you roll. You can now take your brushes anywhere you wish; perfect for workshops, holidays or simply working outside while chatting to Mother Earth.

TIP

This project can just as easily be completed using your sewing machine. Experiment with stitch lengths and thread colours to add your own touch!

TIP

You may prefer to create your brush pockets wider than the ones I've suggested here. Check the top part of your cloth can fold over your brushes comfortably. This gives your brushes a neat fold to nestle into while not in use.

You can use this design for any of your craft or artists' tools. Here is a variation using crochet hooks.

Fallen Leaves 119

AUTUMN

A Fenland Sunset

Eco-dyed wall hanging

One of my favourite things to do is experiment with eco-dyeing. I tuck away scraps of cloth and snippets of lace throughout the year, ready to use at a later date. You can lose a lot of time fiddling and faffing choosing the 'right' pieces to dye, so it's good to get into the habit of deciding which pieces you are going to dye before you begin. For me, fiddling and faffing is the best bit, but if time is limited then having a stash at the ready is a good way to make your creative session more effective!

By autumn, when the nights begin to draw in, I usually have a lovely selection of hand-dyed treasures that I can start creating with.

Creating your log cabin design

In this project I show you how to use one of my favourite patchwork designs – the traditional log cabin – to create a very simple wall hanging using the smallest of cloth or lace scraps.

I've used a selection of eco-dyed snippets to create a gorgeous golden sunset theme inspired by my beloved Fenland skies, but you can, of course, use any colour scheme you like. My cloth snippets were created from eco-dying with red onion skins, turmeric, marigold and coreopsis petals.

Materials...

Selection of eco-dyed snippets of cotton, linen, lace and silk

Piece of calico to use as a foundation base, 21 x 30cm (8¼ x 11¾in)

Piece of cloth for backing i.e. cotton, linen, silk, own printed cloth, 21 x 30cm (8¼ x 11¾in)

Optional: embellishments – beads, buttons

Threads

Step 1

Cut a square for the central piece of your log cabin. Pin onto your foundation base to prevent the panel moving about as you create your design.

Step 2

Add a strip on top of the centre piece. Although I've shown a frayed edge here, you can make your strips neater by turning under the edge with a fold if you prefer. Start with back stitch to secure, then continue with a simple running stitch. Finish with another back stitch. (You will need to do this for each strip you add.)

Step 3

Turn the panel clockwise as shown and repeat step 2, making sure you start at the edge of the previous stitched strip. Continue building your log cabin design by adding strips of cloth, repeating the process with each new strip.

Step 4

You can see my completed design on the left. You may wish to make yours bigger by adding another round of strips.

When your log cabin design is finished, I advise you to cover the back of your work with another piece of fabric to neaten. This can be any piece of cloth you like to use. Sometimes a contrasting colour can add an extra layer to your design, but there are no rules here, so just enjoy experimenting.

Pin your backing onto the wrong side of your completed log cabin design using a folded edge all the way around. You can secure the two pieces together with either a running stitch or a blanket stitch as shown on page 128.

You may wish to adapt my log cabin design to use in another project... You can see here how I have created a journal cover, using a variety of embellishments, lace and embroidery. Think outside the box and enjoy being creative!

A Fenland Sunset 123

INSPIRATION

Blessing
Textile collage

This final project is intended as an inspirational piece, allowing me to show you how to combine various ideas from this book into one textile collage.

I found a blessing online many moons ago and, although it is often attributed as an Apache blessing, it was actually only created for a Hollywood film in the 1950s called *Broken Arrow*. Despite that, I fell in love with the words and have used them as my starting point.

May the sun bring you new energy by day,

May the moon softly restore you by night,

May the rain wash away your worries,

May the breeze blow new strength into your being.

May you walk gently through the world and know its beauty

all the days of your life.

Blessing 125

I started by choosing a piece of embroidered cotton linen with beautiful, embroidered leaves, but I used the cloth on the wrong side as I prefer the calmer version of the design.

I wanted to add a little extra softness to my work, so I placed a piece of cotton interlining behind, but you can use cotton wadding, an old cotton sheet or even interfacing if you prefer. You can of course also work on just the single piece of embroidered linen.

I've hand drawn some of the words from the blessing onto the linen cloth and embroidered over them using stem stitch. I wanted the words to be legible and to add texture to the design, so I chose a thicker thread: a grey crochet cotton perle thread instead of stranded embroidery silks.

126 Connecting with Nature

After embroidering the words, I turned my attention to the edging. I felt it needed a softer feather edge rather than a stark prominent line. I'm generally not a lover of straight, bold lines so a softer edge is always welcome on my textile collages rather than a turned seam or a neatened bound edge.

I hand painted on some homemade herbal paint using a strawberry teabag and gently dabbed the edges to create a soft blush edging.

I have added on a selection of Mother Earth's treasures alongside some embellishments enhancing the details.

It is a beautiful symphony of slow stitching, appliqué, block printing, added textures and embellishments, all creating a gorgeous orchestra of different notes and smiles...

I hope it inspires you to play around with your cloth and threads in a similar way.

Stitchery

Back stitch

Good for outlining, edging and securing stitches.

Blanket stitch

Use for decorative edging and also on small flowers.

Chain stitch

Great to use for outlining and for adding curvy lines on flowers, stems and leaves.

Feather stitch

A delicate stitch that is perfect for meandering or curvy lines.

Fly stitch

A lovely stitch for leaves.

French knot

Perfect for adding texture and for flower centres.

Running stitch

Good for decorative use.

Split stem stitch

Especially good when needing a little more stability to your outlining stitches.

Stem stitch

Use for outlining petals and for extra clarity when edging stems.